PAUL · BERGER

PAUL · BERGER

The Machine in the Window

■ ■ ■ ■ ■ ■ ■

Rod Slemmons

SEATTLE ART MUSEUM

In association with the
University of Washington Press, Seattle and London

Prepared in conjunction with *Documents Northwest: The PONCHO Series: Paul Berger,* this is the first publication in volume eight of *Documents Northwest: The PONCHO Series.* The exhibition is presented with the support of grants from PONCHO and the National Endowment for the Arts.

Catalogue designed by Corinna Campbell
Printed and bound by Graphic Arts Center, Portland, Oregon

ISBN 0-932216-37-4

LC90-052861

■ Cover: Cards: Moon Ram 2, 1989, 30″ x 42″

This exhibition and catalogue were made possible by funding from Patrons of Northwest Civic, Cultural and Charitable Organizations (PONCHO) and the National Endowment for the Arts, a federal agency. Additional funding for the catalogue was generously provided by Jerome Whalen; John H. Hauberg; Sarah Hart; the Sondra and Charles Gilman, Jr., Foundation; Wah and Mei Lui of Yuen Lui Studios; and Chase Rynd. Without partnerships such as this between museums and foundations, federal agencies, and enlightened individuals, public access to the great diversity of art in America would be diminished.

Annie and Leroy Searle introduced me to Paul Berger's work in 1976. I join Paul in expressing gratitude to them for their long-term friendship and intelligent enthusiasm. I would also like to thank Paul for his influence on me over the years and his generous collaboration that made this book possible.

Patterson Sims, associate director for art and exhibitions, and Helen Abbott, media and publications manager, were both strong supporters of this exhibition from its inception: their help and encouragement were essential and are much appreciated. The production of exhibitions and catalogues is an integrated effort by a large team of excellent profes-sionals at the Seattle Art Museum. I would like to thank especially Kay Norton for transcribing the tapes of conversations between Paul and me; Michael McCafferty and Chris Manojlovic, artist/preparators; and Paula Wolf, assistant registrar, for her patience, humor, and hard work on this and many other photography projects over the past six years.

Rod Slemmons
Associate Curator of Photography

■ Seattle Subtext: Display: Memory / World, 1982, 19″ x 24″

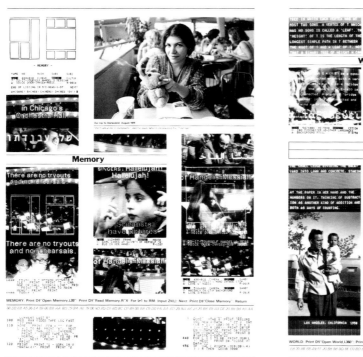

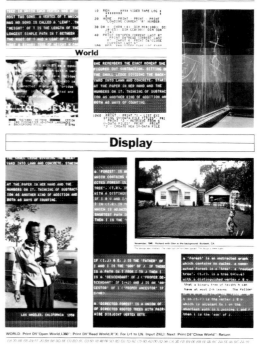

■ Seattle Subtext: World, 1982, 19″ x 24″

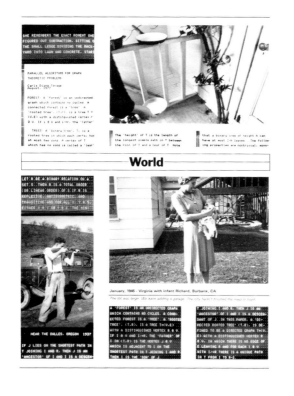

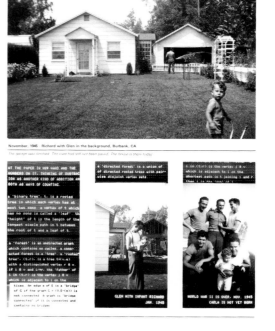

The body of art that Paul Berger has produced during the last fifteen years is built around a core of key structural and conceptual concerns: "the site of notation," the articulated narrative sequence, and the automaton. A survey of all his work reveals a concentrated dedication and clarity of purpose that occasionally seems at odds with his wide-ranging curiosity and eclectic, often confusing subject matter.

Beginning with the *Mathematics* series in 1976, Berger became fascinated with what he calls the "site of notation." He was drawn to the leftover formulae on the blackboards in the mathematics building at the University of Illinois initially because of their formal beauty and the fact that he could work in the empty classrooms undisturbed. As is his habit, however, he became immersed in the project and met members of the mathematics faculty. He found that some of these (to him) incomprehensible marks represented the edge of an exploration into the nature of knowledge and that their elegance derived to a certain degree from the intuitive, gestural frontier of thought they recorded. This site of notation, the place where the hand makes the mark, where thought becomes graphic, became and remains a central concern in Berger's art.

Another is the mechanics of narrative, the articulated sequence. While Berger is interested in telling stories, he is more concerned with figuring out how the sequential narrative, as a generative device, gets the story told. His long-term love of cartoons, both in strips and movies, has led to an interest in how we "read" cartoons—how we are able to interpret a story with a minimum of clues in an arena of maximum illusion and multiple viewpoints. This interest led to the large *Camera Text or Picture* series in 1979 which used a comic-strip structure with frames that often broke loose to float and overlap. Much of the imagery in this project is drawn from televised sports events played within arenas, defined spaces that provide another set of internal frames. In addition to enclosing narratives, frames are a metaphor in Berger's work for the importance of understanding context—frames of reference—in media and popular culture.

His most extensive exploration of narrative to date is the *Seattle Subtext* project, which resulted in a Real Comet Press (Seattle) book in 1984. Taking as his model the conceptual divisions of the news and layout conventions used in *Time* magazine, Berger constructed his own narrative using as raw material images grabbed from video and television,

his own still photography, some family snapshots, and printouts of his computer cataloging system. This complex and dense work braids various lyrical sequences of images and words into a reflexive narrative—each sequence providing metaphors for the others. Occasionally the conventional, simplified news divisions are ironically subverted. The "World" section, for example, consists entirely of an inquiry into his family at around the time of his birth, juxtaposed with instructions for designing a relational filing system for the computer. The snapshots of the pre-Paul family unit are analogous to the computer system that sorts and retrieves images, with the intention of producing collages.

An interest in cards of all kinds—playing decks, the Tarot, baseball cards—and the graphic and conceptual connections between them that allow for a variety of readings led Berger to explore new notions of narrative in his work. He became intrigued with the idea that visual and conceptual connections between series of images can work both in concert and at cross purposes, resulting in interesting internal visual and conceptual tensions. In addition, sometimes the graphic connections can be generative and sometimes relational or transformational. In the first, groups of images work in unison to produce a cumulative meaning beyond themselves. In the second, reordering a series of discrete images can produce entirely different net effects. In his latest series, *Cards*, a set of very large inkjet color prints, he continues his narrative experimentation using a finite number of iconic images pulled, for the most part,

■ Seattle Subtext: Nation, 1981, 19" x 24"

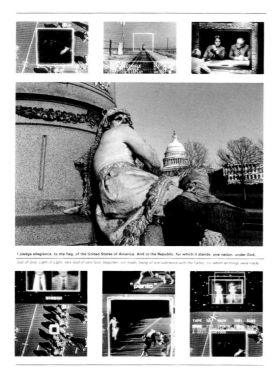

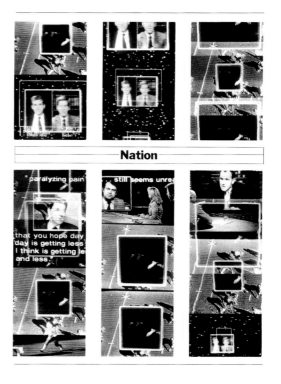

■ Seattle Subtext: Writing, 1981, 19″ x 24″

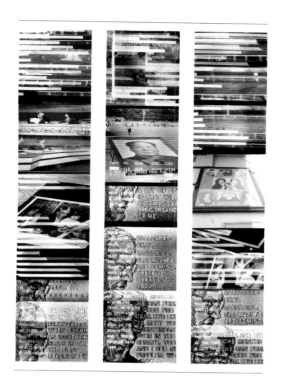

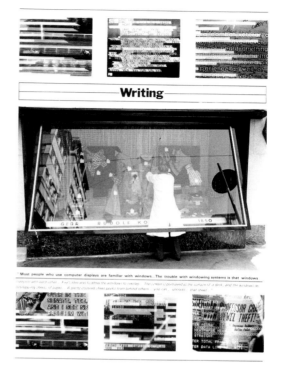

■ Seattle Subtext: Display: Writing and Photography, 1981, 19″ x 24″

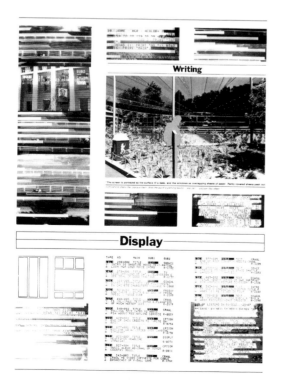

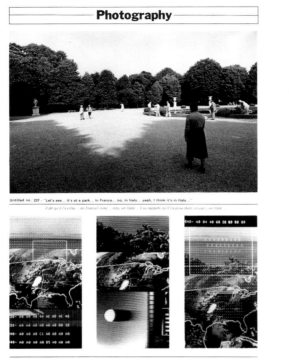

Photography

Untitled no. 237 - "Let's see... it's at a park... in France... no, in Italy... yeah, I think it's in Italy..."

Il dit qu'il l'a prise... en France? Mmm... mais, en Italie... Il se rappelle qu'il l'a prise donc; en part., en Italie.

Satellite photo of farmer's dog at 10⁵ magnification, near Urbana, Illinois

CAT scanning your dog from 27,000 miles in space.

from television news broadcasts. The images are cryptic in their design but are built from accessible and familiar elements.

The *Cards* series is in part an exploration by Berger of the effect of graphic models on cognition. Weather maps with their familiar symbols serve as a central metaphor for defining and categorizing experience with models, which, in Berger's view, congeal references into units we trust and confide in on a regular basis. The spaces between models, however, allow diverse and alternative explanations to fall through: television reporters laying hands on an image of the world always appear smooth and controlled even though the reality they describe might be, and usually is, chaotic in complicated ways. In Cards the recurring image of the exploding space shuttle, in the same resolution and format as the cheerfully self-confident newsperson, represents events not covered, or by extending the illusion, events controlled by the model.

Berger uses the term automaton to refer to any device that can be made to produce predictable results but that will also act autonomously. The camera is an automaton: it can be consciously loaded, aimed, and fired, and its products can be manipulated endlessly. But it always injects surprises resulting from its unique structure and characteristics. This idea of relinquishing some decision making to a randomly acting device derives in part from the surrealists' attempt to tap universal powers of the unconscious by rejecting conscious discrimination in favor of chance combinations of disparate elements in art. The surrealists hoped to unleash

art from conventions of aesthetic forms and traditional content. Berger has incorporated this idea into his own strategy, adopting computer technology that can be skillfully guided but that will also produce unpredictable but no less acceptable results. In his finished works this encourages a variety of interpretations, denies the artist the role of autonomous hero, and develops open-ended criteria for enjoyment and judgment.

Occasionally the notion of the automaton and the site of notation collide and combine: Berger's works often contain precise combinations of randomly collected images. Sometimes both imagery and structure are artifacts of the particular computer hardware or software in use. But Berger's hand is seldom invisible, even if seen only to repeat a serendipitous mistake, like the overlapping negatives in the *Mathematics* series. Berger likes to watch the effect of his hand dipped into the uncontrollable flood of information and references of the media. In one sense it is another site of notation, a point at which he lets the viewer know that there is something to understand and celebrate, which often turns out to be our collective skill at absorbing and processing a tremendous amount of media-generated information.

A turning point in this writer's understanding of Berger's strategies came when the very large *Print Out* wall piece (4 feet by 25 feet) was hung in the Seattle Art Museum in 1986. The installation comprised expanses of computer language—the coded locations for the collection of images Berger has photographed from the television screen since 1981. Over this background of, to the layman, cryptic calligraphy, Berger mounted images generated by an early digitizing scanner. The location marker for each of these images could be found somewhere in the background of writing. His intention was to display all the possible choices as the ground for the images he had chosen: "like posting the rules of the game on the wall," as he put it. This is, in part, a Kafkaesque joke—the rules are meant for our edification yet we can't read them.

In contrast to the sophisticated technology that allowed him to electronically collage text, graphics, and images in *Print Out*, the images themselves were quite crude and occasionally distorted because of the limitations of the scanning hardware. Berger, in a sense, collaborated with the defects of his process to choose images that would remain recognizable after the rough transformation: serious-looking men with coats and ties, military planes, sheep, insects, and his ubiquitous technical symbols and graphs. These images can invoke a different response in the viewer depending both on their new context and on residual clues from their source. For example, the men with ties and jackets were originally television evangelists, government officials, international businessmen, news readers, and actors. In their new, abstracted form, they can be any or all of these—our ability to combine or unscramble them in any context is what interests Berger.

As a fictional construct, *Print Out* functions in a way similar to Walt Whitman's "Song of the Open Road" from *Leaves of Grass*. Instead of a finished product, Whitman provides the reader with a suggestive though lengthy catalogue of locations and connections from which to compile

roof. He is outside of
uman ex
found the program
xcellent insight into so
f the mentalities that
overn the world
apitalist system, all th
ay from the core
ersonified in Rockefell
o the periphery."

at ambassador should
ave been told by you
ithout wincing, that he
as no real idea of the
merican people, that
ases his meagre notio
bout them on his few
ersonal associations.

In 1798 Napoleonic naval forces, accompanied by scholars, invade Egypt; however,

their sea link is cut by the British Navy. In 1799, while assembling stone blocks robbed from ancient buildings to enlarge their fort, Napoleon's men uncover the Rosetta Stone.

ome future young
mericans that
m
felt he was rude to
s you waited too long
oo many times for yo
hance to proceed."

he intense horror of w

ower, why we must
ecognize the spiritu
actors that beat us.
n
nce n
the spiritual aspe
f the war. As
eporter you have a
nique opportunity.
ould help the public
nderstand not why
arines are remorse

Reading

ELEZIONI C
Liste dei candidati per la elezione
CHE AVRA' LUOGO DOMENICA 20 GIUGNO

II COMUNALI
zione di n. 80 Consiglieri Comunali
GIUGNO 1976 (Art. 34 del T.U 16 maggio 1960. n. 570)

301, the French surrender Egypt and the Rosetta Stone, which is placed in the British Museum. Englishman Tom Young's work

he Stone is superceded by Frenchman Jean-Francois Champollion, who declares, "...I shall never recognize originality of any alphabet but
wn.", and completes his translation in 1822. In 1828, Champollion visits Egypt for the first time, and is welcomed as a national hero.

npromises require
dom, and wisdom
s lacking -- with
astrous results."

ty-odd years ago.
as on the other side
the fence when I w
echnical officer and
istant air attach—
German Embassy
f PV report gave m
ed scare because the
inted me of the war
man in the
ted States."

during world war III...
instead of aiming at le
ambitious performance
goals, they tried to
always achieve an
optimum.
Your program has help
give me a little retur
aith in the good work
of man in the
United States."

PROPER NAME

ny friends and I couldr
believe our eyes."

r the "spiritual" aspect
f the war? ... As a
eporter you have a
nique opportunity. Yo
ould help the public
nderstand not why so
Marines are remorseful
over their part in the w
r why another does
ietnam. Why do you
ontinue to seek the

rgive him. This letter
o express as emphatic
s I can my unbridled,
nbounded enthusiasm
nd gratitude for the
wo programs on Iran.
y only misgiving is th

TAPE. NO. MAIN SUB1 SUB2
[037] 164 C-NEWS IRAN CROWD
V:HOSTAGES - BLINDFOLDED ANY-R
A:IN LA-HOUSTON-CAR

are being treated we

and refine his or her own journey. Whitman takes apart the poetic process to make it clearer, although at first he seems to obfuscate. Berger's strategy is similar: like Whitman he would prefer not to be understood easily or all at once or always the same. The multiple references in *Print Out* can be realized only by individual response.

There is a conventional critical wisdom that expects rough work from an artist who thinks as deeply as Berger does and who is politically and socially "oppositional," as he says. David Byrne, an artist similar to Berger in many ways, suspects people who sing on key of not paying sufficient attention to the words. Berger, however, is not suspicious of his own design facility and high craftsmanship. He feels that the visceral and tactile in art form a ground against which learning can take place and from which meaning can be generated. Like Marco Polo, after long journeys of complete immersion and technical difficulty, he returns with objects of crisp visual excitement.

When asked recently to describe his position in contemporary theory and practice, Berger said, "Call me Turbo-Modern." His wit sets him apart in a time when high seriousness concerning photography as an art form has again approached the pre-World War I levels of the Photo-Secession movement. Berger came to artistic maturity during the first decade of the spread of postmodernist criticism and the application of semiotic theory to the analysis of art photography. He has developed a strong disrespect for criticism that simultaneously calls for the Marxist democratization of art and depends on opaque elitist jargon and arcane knowledge. While some of his contemporaries have responded to semiotic theory by producing images intended to be interpreted simply, quickly, and uniformly, Berger seeks out layers of ambiguous allusion and illusion, the more the better, in the charged language of logos and the reduced abstract imagery of popular media. That television goes on endlessly providing more density of reference, day and night, on multiple channels, fills him with awe. He sees it as informational weather, building on the horizon, streaming overhead—just as deceptive, just as unpredictable, just as beautiful.

Berger pursues this metaphoric connection between weather and information in his latest work. He has purchased access to daily radar weather reports and combines these, using state-of-the-art digital computer graphics techniques, with sequenced stills from televised boxing matches and other sports imagery. The latter derives from his use of arenas of different sorts—basketball, race tracks, even beauty contests—in the earlier series *Camera Text or Picture*. The arena, in his metaphoric use of it, becomes the unchanging site and predetermined time period within which random discovery and loss are played out. The latest work continues to explore narration within circumscribed arenas, sites of notation, the complex relationship of figure and ground, and the automaton. He has now left photography, in the sense of using a camera and film, for the seamless arrangements of digitized imagery.

After nearly ten years of learning the intricacies of computers and developing new ways to use digital imaging, Berger persists in his awe of

the new technology: "Some programs leave holes through to totally new spaces inside and that can sometimes be a little scary. I am interested in the faces of the computer, not its interface. This will take many years and is not, at the core, a technical question or desire." Berger's ability to derive metaphor from process and his habit of looking at ideas from unconventional angles has earned him a reputation as a sympathetic and stimulating teacher at the University of Washington.

A common response to Berger's work is that it is interesting but opaque. When discussing this, he points to a favorite cartoon on his wall: a cave man is drawing a horse and his companion says, "I don't get it." After tens of thousands of years, we "get" representation to the degree that it is hard to see it as a convention of thought. Berger is convinced that there are other interesting reasons for and ways of stopping the flow of information, and making and talking about pictures. New phenomena similar to representation have begun to develop rapidly: they demand our attention and understanding. Some are necessarily opaque at first. Walker Evans once said that he photographed to see what the present would look like as the past. Paul Berger makes pictures in order to see the present as obsolete.

Portions previously published in *PhotoEducation,* vol. 6, no. 5, Summer 1990. Copyright by Polaroid Corporation.

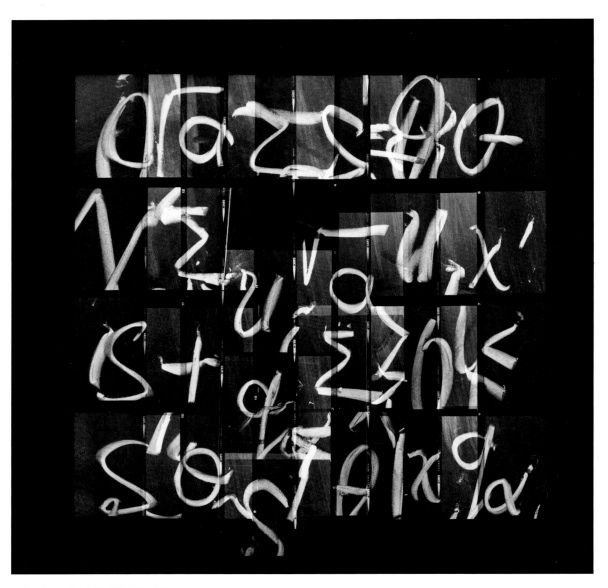

■ Mathematics #62, 1976, 11″ x 14″

RS: You once told a story about a strange experience you had with a coloring book when you were a kid. Could you tell it again so I can remember it precisely?

PB: I was three or four, and my parents had friends over, so it was a special time when I could be in my room out of sight and they were doing whatever adults do. I distinctly remember coloring in my coloring book normally, then there's a gap, like blacking out. The next thing I remember I was drawing on the wall. I'd discovered that if you put a crayon between each finger you could draw these lines that had a compelling coherency. Whatever it was that happened to me was so powerful it broke the coloring book. The coloring book fell away and I was just doing it on the wall. I don't remember getting from the coloring book to the wall but my mother says I was standing in one place and just doing these concentric marks as high and as far as I could reach in each direction. That was her image of it: rooted in one place and seeing how far from that spot I could mark. But all I can remember seeing is the hand and the lines trailing behind it, so it was the hand rather than the total marking or picture that concerned me. The strongest part of the memory is the gap —somehow I figured out the multiple crayon device and then, boom, the normal coloring book thing dropped away.

The first picture that I saw of yours was one of the Mathematics *series in Rochester in 1977. Those images seem visually related to the childhood story. How did that series start?*

It's kind of complicated—I'd been making photographs around the campus at the University of Illinois where I was teaching at the time, looking for evidence of mental activity, I suppose. In doing so, I eventually stumbled into one of the oldest buildings on campus, Altgeld Hall, the mathematics department. That place stopped me cold; it was filled with blackboards, real slate blackboards that wrapped around three walls. They were daily, hourly, filled with the stuff of mathematics. I made a few exposures there with a Mamiya C3, which was old even then, and not in great shape. It had trouble with the film winding mechanism, so there were some partial frame overlaps within the roll of film. The overlaps happened to occur in close-up images of the blackboards. Because the blackboards were dark except for the chalk marks, the overlapped areas were not obliterated with overexposure the way you might expect.

Instead, they simply became lighter surfaces that came forward from the rest of the blackboard background, creating new and synthetic surfaces. After that I started doing overlaps exclusively.

The Mathematics *series began with a camera failure while you were wandering around aimlessly?*

More or less. It happened by accident at first but became a technique. The cocking mechanism and winding mechanism were separately controlled, which they aren't in most cameras anymore, so you could partially advance the film and still cock the shutter. And you could control it. You could distinguish between a quarter and a third of a frame with regularity.

I also met a woman, Carla Savage, who was a PhD candidate in the field of autonoma theory, which is a specialized field within mathematics. Through her I got to know a group of graduate students, and went with her to some faculty/grad seminars. I also got to know a mathematical maverick named Klaus Witz, a former mathematics professor. In his career, Witz had done good solid research, consciously tried to take on new fields all the time, always trying to move forward. He told me that he had decided when he was young that he wanted to devote his life to the "big questions." So, of course, this lead him to mathematics. After going through the most rigorous graduate school training, doing all this teaching and research, it was still somehow not enough. So he launched into a whole new thing: he went to India and had a guru and did all this spiritual stuff, which was also not enough. So he came back to U of I and started a Committee on Culture and Cognition, in the education department, and ended up doing analyses of consciousness states. He was interested in open- and closed-eye imagery, a study of daydreams. He found a student who was ordinary in every way except for her ability to overlay imaginary "creatures" onto everyday reality. When she was a child in school, and bored in class, she would continue to watch the class, but would have a horse come into the room and interact with what was going on. She got really good at it to amuse herself. Witz would experiment by having the woman bring the horse into a dark room, and then he would set off an electronic flash to see if she saw it illuminate the imaginary horse. Witz was really out there. He also still loved mathematics, you could tell, and thought of the field as a "group-mind" that was entered into by each mathematician. He also thought of the teaching of mathematics as a dynamic arena in which students were initiated into a real but noncorporeal "place." I was fascinated by his notion of that arena, that place. Although I couldn't follow the actual mathematics, I could visit the site of the interaction, the point of contact the chalkboard allowed. The professors talked during class, of course, but the blackboard was where both professor and students saw things happening. What the professor said clarified or contextualized what he wrote. Everyone was glued to the writing. Because they're drawn with human hands, these amazing abstract writings have a human tracing to them.

A physical gesture.

A gesture, a speed, an emphasis, and individual differences between the various instructors.

I tend to think of the mathematics pictures first in terms of calligraphy. They are beautiful in the same way Japanese texts are, and similar in that we non-Japanese know they mean something but we don't know what. Another response I have is to the blackboards that we have seen all the way through school: the writing on them was always right on the edge of what we could understand, usually a little ahead of us.

Especially as they appear in unfolding time, because you're thinking, whoa, all these deltas and sigmas and stuff—but you just wade in.

It either leaps out as meaning to you or you just don't get it and hurry to copy it down.

Right. And I was curious about how the mathematicians saw what I was doing. I got permission to photograph, but nobody really got what I was after. I talked to a prof who seemed promising, but after a few minutes his light bulb went on and he said, "Oh, okay. Here's one of my favorite equations" and he drew the equation neatly on his chalkboard and then stood back and let me photograph it. But by that point I had met Klaus Witz, who could tell me everything I wanted to know about the dynamics of engaging in mental combat at the blackboard, the site where one melds into the mathematical group-mind. To him the blackboard was a

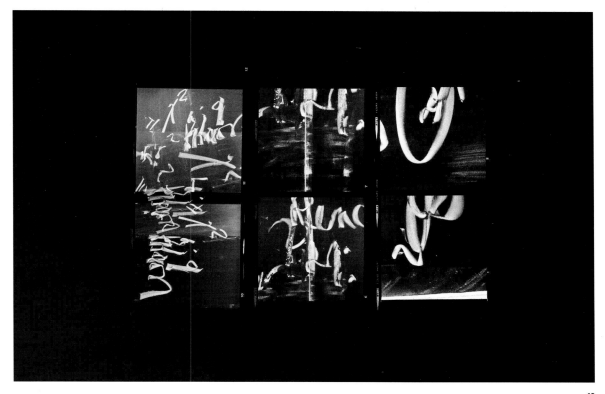

place, a battleground, a ladder, a stairway to that collective idea—almost mystical in dimension.

I guess I don't automatically associate mathematicians with mystical discovery.

It's unfortunate that most people don't associate visionary ideas with math, or think of it as a rich and varied domain. I was also interested in the graduate students and what it was like to teach that level of mathematics from scratch, because most of the calculus classes were taught by TA's. What was it like to try to communicate those difficult notions to a sea of undergraduates?

The eraser and the residue make a nice reference to that break point between rote learning and active, creative participation. I mean that point where you enter the excitement of the idea chase and stop desperately trying to copy everything down so you can study it in private.

Yes, there's a primitive nature to the exchange that is seemingly very "low-tech" but accomplishes a great deal. If there were a machine that could translate words into drawn notations and images in real time—as if the prof could just speak and have what he said drawn onto the blackboard in perfect, neat typography—what you'd gain would be literal, surface legibility. What you'd lose would be the information communicated by the layers and the rough edges, the hesitations, the emphasis that the hand-drawn gestures report. The board, with its background of erasures and its stacking of symbols and their linking, becomes part and parcel of the argument.

That's interesting, because then it is abstract and concrete simultaneously.

And there's this cloudiness that is the erasures, the edges of the discussion from the previous day and it's like this cloud from which new ideas are floating out—they're white too—so they really stand out.

Did you expect when people saw those pictures that they would pick up on all that? Did you ever provide an explanation when you exhibited that work? What did you think people were seeing?

Well, they were seeing spatial landscapes, in the sense of a space that was obviously composed of parts. It wasn't a natural landscape, so first and foremost it was spatial and synthetic. Second, it was obviously notational, and I had been interested for a long time in the combination of text and photographs, not so much in terms of linguistic theory but something much more mundane. When you see photographs most of the time they're together with text in advertisements or books or magazines—so I was interested in playing with that and I wanted to find some situation where the two would be as closely linked as possible.

At the time we are talking about, from '68 to '70, one of the strongest voices in photography was Minor White. You seem to have in common

■ Mathematics #61, 1976, 11" x 14"

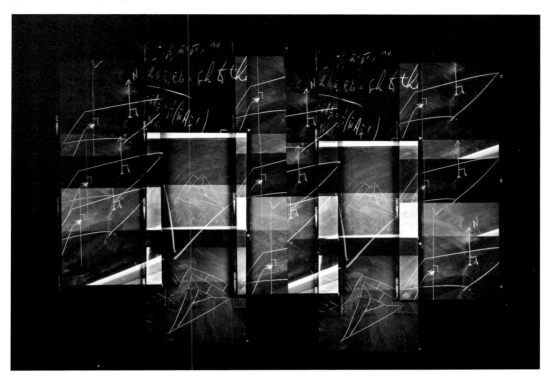

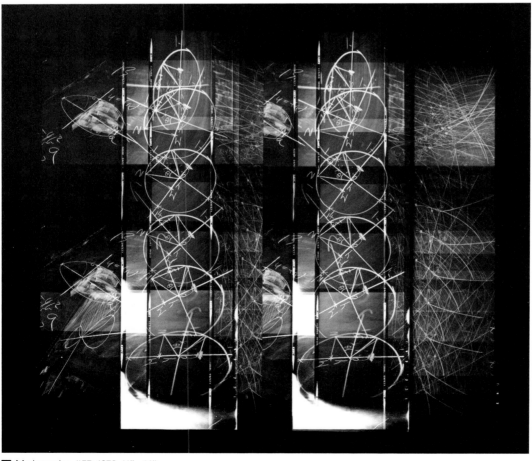

■ Mathematics #57, 1976, 11" x 14"

■ Mathematics #15, 1976, 11" x 14"

with him a huge constellation of ideas that you immerse yourself in and mine for your art. Some of those ideas are evident in the pictures, but most of them aren't. As opposed to Robert Heinecken and Ed Ruscha who were trying to get as much information into the picture as possible, so that the viewer had fewer choices as to what the picture was about. With yours they have a lot of choice. And with Minor White they have a lot of choice, too.

Yes, the choices are there for the viewer. It was very important to me that the pictures were visceral—that they were beautiful.

When you have had your work in exhibitions such as Stills: Cinema and Video Transformed *in 1986 and* Eye of the Mind, Mind of the Eye *in 1988 with photographers who were working on a fairly cerebral level—or at least dealing with ideas more than with formal issues, yours stuck out as being formally exciting and intriguing, whereas the others tended to be kind of crude.*

In the *Mathematics* series specifically, the real formal beauty is from the mathematics itself—I was only recovering evidence or traces of it, like an archaeologist. But because the traces were not from everyday artifacts like vessels and tools but rather the mental constructs of mathematics, it was the space of "mental transmission," as evidenced in human gesture, that was the arena, the site of its beauty. It is also an arena that is decidedly dynamic, yet what I would photograph would be a still point— what was left at the end of the class. As I engaged that site, the photographs took on their own life and structure, by being filtered through the overlapped exposures. That was my part in it.

Why did you do that? Why did you feel you had to pile them up when, in a sense, they were already piled up, layered?

Because I thought a straight shot of the room, or a close-up of the blackboard, would be a very different proposition. There would still be a sense of the activity, but it would be from a literal point of view, and the view would still be located in "real" space. I had to somehow alert people that I was looking at something else. Not "look how beautiful that blackboard is" but to try to hint at the idea forming itself in the mind of the person who is watching the lecture—not a perfect analogue to it, but a visual trace of the activity.

So you would prefer the form to alert the viewer rather than make the ideas explicit.

I would like to see the idea assemble itself in your head when you look at the image because your mind really does want to think of it as an actual space, as if you were behind or inside the blackboard. If you saw the edge of the room, or other clues to three dimensionality, you'd say, okay, I'm in *this* room looking at *this* blackboard. If you don't have any of that, then your mind will just automatically—and it's not intellectual—posit that image as a discovered space and assign it qualities independent of a real room.

Your work is clearly experimental in both form and content. Where do you place yourself in the genealogy of contemporary American experimental photography?

I would say that I'm second generation in that process. I think people like Thomas Barrow and his peers from the Institute of Design were the first generation working within the educational system on explicitly experimental pursuits. I graduated from high school in 1965 and it was really the first part of the '60s when photographic education as we now know it started to grow on a national scale. I'm definitely from that generation and environment, although I don't know that I'm particularly representative. There were, and are, plenty of photographers coming out of that kind of environment who photograph "the real world" even as there were much earlier photographers who photographed "synthetic worlds," like László Moholy-Nagy or Man Ray. But because most photography programs today are within university settings, I think students are used to dealing with a wide range of methodologies and concepts.

Actually, I had a complicated entry into photography and education. I started at Art Center School in Los Angeles in 1967, which was a very commercial place. In fact, it was a rather retrograde place by that time, after having been very innovative in the 1930s and '40s. I became friends with a wonderful man named Albert King who was one of the founding members of Art Center, which had been started in a very idealistic, utopian mode patterned after the New York Art Student League and the Institute of Design—almost a "bauhaus west." They would refund a student's tuition if they felt that they were wasting their time. Albert King's life was devoted to color. He barely graduated from high school in 1915 because he wanted to study both art and science. He read his father's complete collection of *Scientific American* from issue number one: that was his training. He never went to college but became an expert in color theory. But his life wasn't just theory: he had been a cameraman on Cecile B. de Mille's *King of Kings*. He also did experiments with an early two-color film process and finally decided that since ceramic glazes were the most permanent color, he would become a ceramist. He rediscovered certain Chinese glazes. A fantastic, inventive, but noncommercial guy. As Art Center became more commercial, especially after World War II when they smelled the GI Bill money, he fell into disfavor, and was eventually let go from Art Center. No place for a true Renaissance man, I guess. When I came there in '67, there was actually a dress code! No beards, and you had to keep your shirt tucked in neatly. At the same time, the design scene of the late '60s was changing everything, and the Art Center people knew they had to loosen up, otherwise their graduates would be so square they couldn't get into the biz. When I was there, anything but a 4 X 5 camera was forbidden until the third semester.

Still, it seems like an advantage to have worked in both the technical and fine art areas early on.

It was an advantage. There seemed to be no single place to get both at

once. The work I was doing at Art Center was mostly oppositional. There was a classic, decades-old assignment there called "The Industrial Book." The idea was that you would go to the Twinkie Factory, or whatever, and trace the process of manufacture from raw materials to finished consumer product. That seemed like a tedious idea, so I chose to photograph the Cleveland Wrecking Company demolishing things. I rendered it with strange duotone solarizations, splattered developer, Kodalith manipulations, etc. It did end up in book form, however, and did have a nice sequence and dark flow to it. It was accepted.

So it was possible to do some experimental work at Art Center.

Yes, and there was a small group of people who encouraged each other to do so. Ironically, people like Wynn Bullock had been at Art Center in the '30s and had done a lot of experimental work. And in '67-'68 Todd Walker was teaching at Art Center, and was a major force in the revival of so-called alternative processes. I went five semesters to Art Center, longer than I'd really wanted to, and then finished a BA degree at UCLA. Robbert Flick was an important influence in my transition. He had come from Canada in '68 to study at Art Center, whose backwardness horrified him. Since he already had a BA degree, he was able to switch to UCLA after discovering Heinecken there. I went from this straitlaced commercial school to UCLA which was a wild place to be, as was Los Angeles generally for all the arts. Ed Ruscha was teaching painting there. Heinecken had been joined there by Robert Fichter and they both had lots of interaction with Todd Walker. It was a hot place. At UCLA I actually did a lot of straight stuff, straight 35mm. Probably the most successful project I did as an undergraduate was to make pictures from the passenger window of my van with the edge of the window in the frame, making two frames. I printed them on different gray grounds which added another grounding element—the image moved fore and aft.

As you did later with the Camera Text or Picture *series?*

Yes, exactly. The one idea grew out of the other.

So very early on you worked with the idea that the photograph is a flat field of information, not a window. By showing the frame, like a proscenium arch in a theater, you state up front that personal choices are being made, attitudes are present.

It also precedes a lot of things about the thesis I finished in 1973 for the Visual Studies Workshop, which was also in book form. I don't know if you ever saw the original.

No, I didn't. One of your classmates was just telling me that your thesis was taking a Super 8mm movie and blowing up the frames.

Oh no, that was another project. The first year I attended VSW, partly in opposition to Nathan Lyon's heavy 35mm thing, I decided to do these Super 8mm films, and did slow projection at six frames a second. It

seemed interesting because it would be somewhere between slides, prints, and film. I played with that the whole first year. But I didn't do any prints from them, they were just films.

So what about the VSW thesis book.

Actually, it's a long story. After my first year at VSW I was tired of graduate school and uncertain about pursuing film, so I took a year off and worked at two different jobs. The first was very important to later work. It was in a branch of a civil engineering firm that did reprographics work. I ran a big 42" process camera and did all kinds of Kodalith and autopositive work as well as aerial photography rectification prints and diapositive stereo plates. This opened up areas for me both in materials and scale, not to mention a whole new way of thinking of visual information and rhetoric. The next fall I started teaching photography three-fifths time at the high school I had graduated from.

In Davis, California, your hometown?

Right. It was a strange experience. I had graduated in 1965 and it was now '71, so I was just six years out of high school, and most of the same teachers were still there. I identified much more with the students than the faculty. We were supposed to teach photography with one enlarger. I had three classes, so I had to think of other stuff to do. I would bring scrap materials to school and we'd fool around with paper negatives. I had to be kind of inventive with it. It was a great progressive group of kids, kind of post-hippie generation. The smartest ones didn't go to college. They had a video camera and a tape recorder because it was an up-to-date university high school. So we'd make these goofy videotapes and do interviews with the vice-principals.

But there was a catch. At that time in California you could get permission to teach without an education degree only if you took a special class. I had to go to Berkeley every other week and learn how to use chalk and the overhead projector. I also had to take a photo test to qualify for teaching photography. I got a C-minus on the test, which was like dada theater. They would give you a speed graphic and Super XX film to make an exposure and they wouldn't tell you the ASA or give you a light meter. Then you had to develop film but they wouldn't give you the development times. That was the test.

Seems like it was a test of your patience.

It was called a methodology class. The instructors would visit the schools where we worked and give us feedback and advice. I became friends with a group at the high school who were all sort of like me in the sense of being wiseguys and oppositional in relation to the situation. The school held a career day every spring. A local insurance salesman or car dealer would come and give little talks. So our group held an alternative career day. We invited the most deadbeat kind of people who had gone to that high school to come back and give testimonials. We did it as a performance piece in the class that my methodology instructor was going to visit.

The first testimonial was a gangster movie situation with a projector—it was hard to tell what was going on. There was a kid on the floor with a projector going with no film and other people acting like gangsters playing craps. At the same time, three guys who were in a band, very verbal, very quick, and real tight—normally the class cut-up types, but all those people were recoverable in my class—doing routines and playing marches and intermission music.

Of course, all the vice-principal types in the school were horrified because they saw hellish visions from the past. Each of the former students, one of whom was a dishwasher, gave a testimonial. Some of the photo students were hooting and yelling and others didn't get what was going on. One big former student with very long hair, the most accomplished in the sense that he had become road manager for the band Joy of Cooking, got up and he turned the whole thing around. He chastised everybody for wasting their lives screwing around, and gave this whole "work hard, fly right, don't turn out like I have" speech. Everyone was suddenly silent and transfixed. He went on and on, and then it was all over. A two hour thing, unplanned in the sense that I had no idea what would actually happen. Afterward, my instructor from Berkeley came up to me and said it was incredible and asked if that happened every day.

Maybe you could comment a little on the Visual Studies Workshop thesis book.

After I did the high-school thing for a year, I went back to VSW. The earlier Super 8mm films that I had been doing were a way of loosening up camera vision—both because it was crude, and because it involved sequence and flow. When I went back in '72, I ended up doing a text and photo book—called *Daily Life*. It was an extension of trying to figure out the relationship between text and pictures, something I am still working on.

When did you start working on the text-picture relationship?

In a more traditional way, pretty early on. In 1968 a friend of mine from high school and I collaborated on a photo-text project about his grandfather who had been a pioneering scientific farmer in the 1920s and '30s, using then advanced practices of hybridization and so forth. The man had been a very strong childhood figure to my friend, a hero and model. When we went there, the man was old and cranky, and his farm was in shambles, although you could tell it had been a vibrant place once. We collaborated on a giant-sized book with text embedded in photo pages. It was kind of dark and funereal, 16" x 20" black pages with reversed-out text. It was important to us that it not be a standard text/illustration proposition, but would be almost posterlike in its construction. My friend's writing was more poetry than prose.

We mostly see photographs in connection with words—in different relationships that usually are not clearly understood. For example, what do captions really do to a picture? How do photographs illustrate a text? Texts are usually closed, linear, with a beginning, middle, end. Pictures

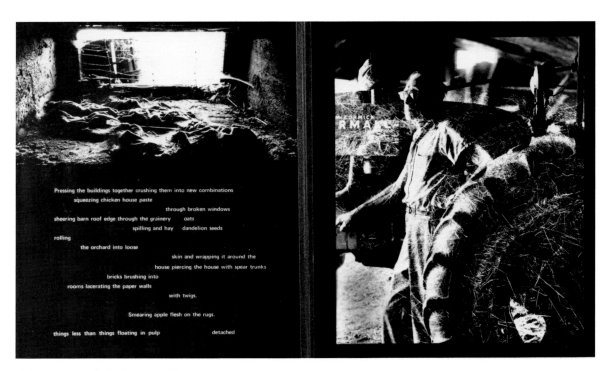

Pressing the buildings together crushing them into new combinations
squeezing chicken house paste
through broken windows
sheering barn roof edge through the grainery oats
spilling and hay dandelion seeds
rolling
the orchard into loose
skin and wrapping it around the
house piercing the house with spear trunks
bricks brushing into
rooms lacerating the paper walls
with twigs.

Smearing apple flesh on the rugs.

things less than things floating in pulp detached

■ Excerpt from artist book Roots, 1968

are open to various interpretations depending on which details you draw out and combine, conceptually. At the same time, captions usually reduce the meaning of photographs by limiting the possibilities of interpretation. So for my VSW thesis I decided to do a book that would reverse, or at least mess with, the normal relationship between the two. For text, I used clichés I overheard during breaks at a warehouse where I worked temporarily. I was an outsider, so I just sat and listed all the clichés people used, people who had known each other for years. Their conversation was reduced to these stock phrases.

You used handwriting for the text, your actual notebooks, in Xerox form.

I did that to make it less slick, more immediate, maybe more gestural. The pictures do not exist in any linear or narrative form. The words simply energize the pictures in various ways, sometimes pages later. The pictures return to certain forms and images in a looping or spiraling fashion. In fact if you look, the last picture is very similar to the first, so you could start over, with all the text and pictures in mind. This would, of course, make the second read-through generate a new set of feelings and associations. I had started to think of the book as a transformational, generative device. Later, I would call this the automaton or black-box principle. It worked pretty well. I passed! Actually, it was an important step for me.

Just to get the sequence of events straight, what was the progression of jobs and projects after you left the Visual Studies Workshop?

My first job was at the University of Northern Iowa in Cedar Falls in 1973-74. Then I went to Illinois—Champaign/Urbana. That is where I

2.

*If she would have heated me that way
I would have kicked her in the ass
Doris.*

*grow like a weed; run like the wind; play
it by ear; pull your own weight; jump
to conclusions; can't find the words; don't
have the heart; stick to your guns; one
of these days; the whole ball of wax;
dig your own grave; clear as mud.*

Daily Life

like a broken record.

■ Excerpts from artist book Daily Life, 1976

*learned his lesson; that's cutting it thin; times on my side; read you
like a book; get a load of this; bored to tears; clear as a bell;
thanks for nothing; better safe than sorry; flat as a pancake;
a word to the wise; a slap in the face; all tied up; standing
on thin ice; end of my rope; at wits end; toy with my affections;
saw right through me; misery loves company; roll with the tide;*

did the *Mathematics* series, in '76 and '77. Then I was hired at the University of Washington in 1978. Before I left Illinois, I had begun to make multiple exposures right from commercial television—that resulted in the *Camera Text or Picture* series. I also did some overlapping exposures in two series of relatively straight camera work, *Cycloptic Sets* and some pictures from a trip to Europe. All of these projects involved layers of exposure and information—recombinant imagery.

Then when you got the computer in '81, you could store images from TV and realign them later. But you did a lot with video imagery before you got the computer.

Yes. In '81 I still couldn't create a true digital video image, but the computer allowed me to have a data base of all the snippets I was record-ing onto videotape. I had a VCR, but it was not the widespread kind of home appliance it is now. I used the computer, then, first just to catalogue and sort through videotape elements. But since I used the same video monitor to view the videotape and display the computer screen, a single camera mounted in front of the monitor could double expose both video and computer information. At that time I had no way to do it elec-tronically, but I could photographically.

Was there a larger set of ideas behind the Camera Text or Picture *series, equivalent to the interaction you had with the mathematics teachers at Illinois?*

Yes, but it's a lot more diffused.

What was it, TV in general?

Well, it begins with the experience of watching broadcast television. Although TV exists in real time and you can control it by changing the channels, you can't stop it. It just keeps going. VCRs were not so com-mon in '81. But even now, when they are, people seldom use them to stop-frame or analyze what they see paraded in front of them. They use it mostly to offset the time they watch a show, but they're watching it in the same way—passively. You can never "catch-up" with TV; it just keeps spewing at you. I was thinking about the transience of it a lot at that time. It occurs like a weed, and is gone.

Like erasing the mathematics classroom blackboards, more or less.

Right. But normally you have no way to recover what TV spews or your reaction to it. Something happens to you and maybe what you remember is more in terms of the form in which it was presented than in the actual content, so I needed to reconstruct the experience in a different way. It's the tracing of TV events in that sense. Seeing the horse race on TV, or my version of it in the *Camera Text or Picture* piece, wasn't really about the horse race. That clearly is not the way to understand who's winning and when and all that. It was more like a tracing of what that total event was. And it was a simple sequence but not common, in the sense that the most common presentation of sequence would be like Muybridge's *Ani-*

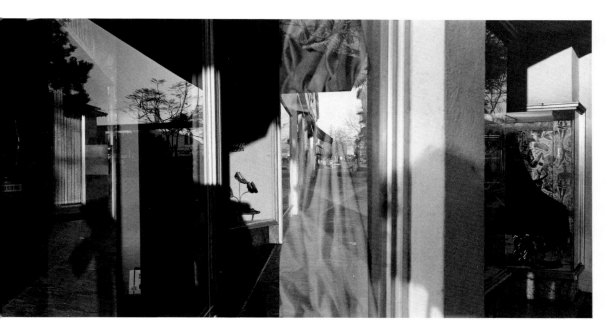

■ Cycloptic #2343, 1978, 11" x 14"

■ Europe #4, 1976-77, 16" x 20"

■ Europe #9, 1976-77, 16" x 20"

mal Locomotion plates, left to right, top to bottom, each frame clearly distinct. The strips in *Camera Text or Picture* were distinct enough and sequential left to right, top to bottom. But the overlapping images gave me ways to emphasize one thing over another. They are a different report of the horse race—different from how it was reported to me, and in a different matrix, a different form. So you can notice things about the race that are similar to, say, a football game with its edges and boundaries. Maybe that series wasn't about football or horse racing or whatever, exactly, but it was about boundaries.

So you're really trying to turn the flow from the TV screen into a new brand of sequence, actually trying to hold it back.

Or create this machine, this special camera—it's like my version of a picture of TV. I set up the mechanism to run itself—an automaton. My automaton performs, and the pictures come out of it—that's my version of it. That's one way of reporting back on what happened. But it is much looser than the *Mathematics* project, it's not a specific world.

By distancing yourself from the process and loosening up the result, you seem to be counting on a visceral, maybe even an intuitive response. Is that because the information is suspect to begin with and not quite as interesting?

In the case of broadcast TV the information is always suspect. What triggered the whole *Camera Text or Picture* series was specifically that horse-race image—maybe because it looked a little like the math pictures and was a tracing of activity, or maybe because of the almost comic relationship it has to Muybridge's *Animal Locomotion* pictures. Also, it is a defined activity that everyone is familiar with but is not strictly narrative—each horse race has a different "story" to it, but the field of play and its progression is known to the viewer. The *Camera Text* as a picture machine is a way of taking apart the horse race and reordering it. Muybridge may have fired up the sequence machine, but he certainly didn't close it out as a visual proposition, as a way of seeing. The horse race is a literal but visually rich form of tracking. So it's both rich as a conceptual arena and engaging as a punchy, highly graphic image. I don't think I ever start from just an idea alone or a visceral connection. It's always a partnership.

Which actually is different from what I was saying before—relating you to Minor White. He in fact did work, or at least he said he worked, from the idea first. But you seem to be somewhere between White's proportion of idea to picture and, say, Friedlander's or Winogrand's proportion of intuition to result. It's an odd, unique mixture in your work. You're letting constellations of ideas affect you but, in fact, you talk consistently about form, finding internal frames that will alert the viewer to the notion you're trying to explore. When you talk about the ideas, like mathematics, they seem paramount, but they are manifested in visceral imagery. You talked about the frame of the van window, and violating

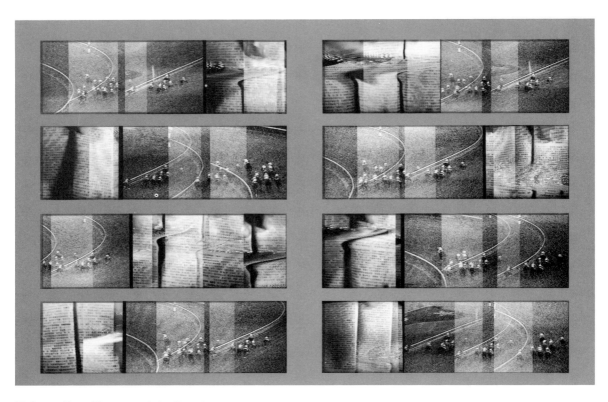

■ Camera Text or Picture #2, 1979, 19" x 24"

the frame of the Mamiya but creating a new internal kind of frame. It seems you're particularly conscious of having the proscenium arch be visible, so we don't lose track of the fact that there's a hand at work.

That's what the frames are—proscenium arches. I wouldn't have said it at the time but that's how they function.

Why did the Camera Text or Picture *series take that specific form: blocks in a grid?*

Well, I originally thought of them as a book form, like a double-page spread. This is personal preference for some kind of format no matter how loosely defined—like the math pictures had their own kind of a format—so that it can be understood as a thing with parts. If you change the format all the time, then it's hard to see what you're tracking on. But if you think of a format as an instrument, no matter how obscure in its construction or history or whatever—however eclectic in its origin or evolution—once it becomes a machine, once it's settled, you can start looking and maybe what you see through it is useful, and maybe it's not. But at least you know you're looking through this instrument from this particular point of view.

The closest I have come to understanding what you are up to is an expanded version of what you just described: we're all looking through an automaton of some kind that we have incorporated wittingly or unwittingly. If we can watch you make one up and play with it, and understand the model, it gives us a better chance of understanding the

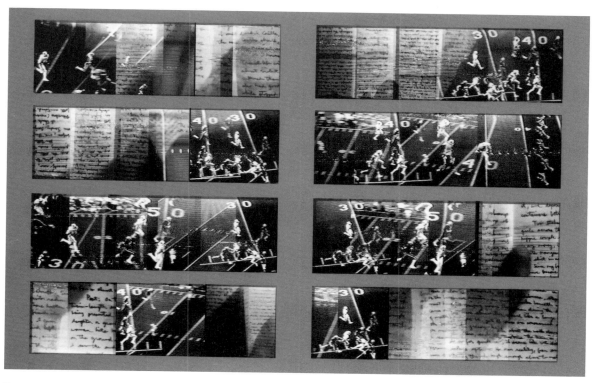

■ Camera Text or Picture #5, 1979, 19″ x 24″

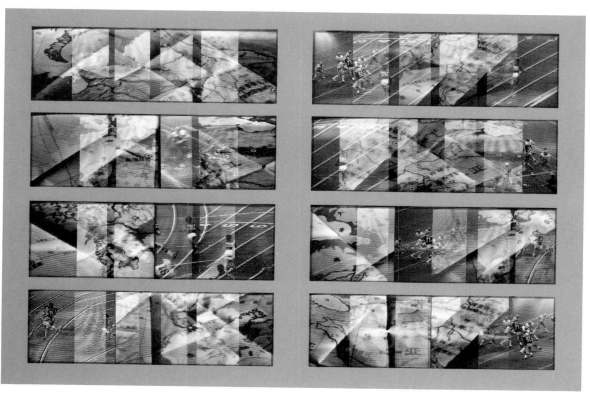

■ Camera Text or Picture #9, 1979, 19″ x 24″

automaton that we are, or that our perceptions have made us into.

That's a fair assessment, but I would maybe change the emphasis. It's not just that we need to be aware of the series of "machines" that mediate and often limit our perception but also that we need to consciously and consistently explore ways in which we build our own new ones, or look through someone else's. Further, we can often find that what we thought was a special-purpose or limited machine can in fact hold other possibilities. Muybridge is a perfect example of that: we couldn't care less, really, whether or not a horse sometimes has all four feet off the ground, but it does intrigue us that his machine supplies a visual methodology for evoking the invisible fourth dimension—time. It's just that people take Muybridge, and other visual machines, so literally, or refuse to see the other possibilities embedded within them. The daily weather satellite photo loops are another good example of this. They are really quite beautiful, too.

In a sense then the earth becomes an automaton—you've got two levels of machinery going there: the machinery of the weather and the mechanism of the record of the weather. Isn't there some general information source for those weather images?

Yes, that's where the new maps I am using come from. Through a modem I can connect directly with a weather service that provides hourly images. Currently they are radar images, not satellite photos, but that is coming soon. The important thing is that the "imagery," like the daily drawings in the math building at University of Illinois, is always being generated; it is a complex and compelling pattern that is always there to be seen. I also like the idea that the weather maps are generated by their own visual jargon. Like the math blackboards, they can be covered in this crypto-symbolic way. They're several layers of abstraction deep already. And they become a ground like the listings in the *Print Out* installation. The weather maps satisfy a lot of my requirements: they look interesting, and they really are maps. They're an abstraction of real world events on a global scale. And as an array they have the advantage of being like a cartoon in the sense that they follow events from frame to frame, always move from left to right, yet the map in the background is the same every time. I like to think of it as moving over the information in a glass bottom boat, seeing things that are connected only in your mind.

The computer, and the set of intellectual models it provides, has been very important to you, but your use of it has evolved considerably.

I bought my first computer in 1981. One of the reasons I got it, as you mentioned, was to create a retrievable data bank of images to work with, since I was by that time pretty much exclusively shooting off of television, and I was recording stuff on tape to shoot later. There had to be some way to find what was on the tape. I started keeping logs on a columnar tablet, but that was impractical. You couldn't search through the tapes efficiently, since I just had a crude frame counter on my old

VCR. When I got the computer, I actually wrote the data base program, which is really odd, looking back on it now. I had a TV monitor as opposed to a television set, better quality, that I would use for both the display from the computer and the videotape image. So through multiple exposure it was easy enough to expose the computer image on top of the video image. It wasn't combined electronically, like we do now. Now we can mix and blend all kinds of text and image. But at first the lists themselves, in the form of computer screen text, became part of the piece conceptually, since they access, in a sense, the entire body of all the videotape imagery. That's how the whole new body of work started. I'm not photographing off the screen at all anymore. I'm using the digital information directly to make large-scale inkjet prints. Mixing image and text digitally is now commonplace, but when I wrote my data base program, the listings did "leak" into the TV image as a kind of self-documentation.

I remember the day the computer arrived. You became completely immersed, as you did with the mathematicians at Illinois. You learned a lot about how the computer works from Leroy Searle. That immersion seems to be a part of your general strategy.

Because I tend to work in discrete series, using up one machine and then consciously moving to another, the immersion is very important. I don't like looking out the same window all the time. The computer was a new challenge because it is such an infinitely reconfigurable device—truly a general purpose machine. By programming, I became both more familiar with and appreciative of the complexities and possibilities of the machine. In '83 I bought a crude, slow digitizing card for the Apple which was a non-real-time frame grabber. It could digitize a frame of video in about 15 seconds in crude black and white.

So why was that useful to you, because you could take apart the digitalized signal and reform it? Distort it?

That was the first time I could get a digital version of an image. Before, there was digital text and line information that was double exposed into video imagery, but there was no way to get an actual video image that was digital. Actually a lot of the black-and-white images from *Print Out* were done with that original board. It's pretty distorted anyway, because it's very low grade, low resolution, and just black and white.

I am still not clear as to why you wanted to get to the digital level.

If I could get a digital version of a video frame, then I could manipulate it freely as well as combine it with text and line elements generated separately from any source.

An image without a camera, is that what you're saying?

Well, it was originally formed with a camera of some kind at its source— either film or video. But I was getting a version of it without the aid of a lens, yes. Since it took 15 seconds to scan a video frame, and the scanning proceeded as a vertical slice from left to right, if anything in the video

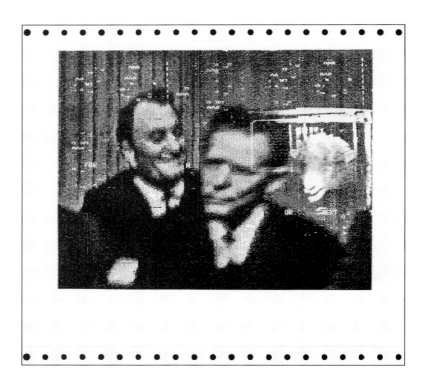

was moving, it would be distorted and smeared. Faces, for example, as they moved up and down or looked left then right would be smeared by the passing vertical scan—a sort of automatic and quantified Francis Bacon.

So in a way it's like the double frame of the camera when you shot the blackboards. It is both an artifact of the malfunctioning technology and of your decisions.

Yes, but there was also something new at this point. The "distorted" wavy images were a transformation that the eye could never see. It wasn't like a long time exposure, as in photography, where all areas of the picture plane are built up over the same time. It was a digital sampling of a thin vertical slice that took 15 seconds or so to make its journey across the picture plane. At any one time, any particular vertical slice was a frozen slice of that part of the picture plane, but the travel across the plane was so slow that the resulting transformation was visually unpredictable. I worked largely with videotape segments of talking heads. Talking-head figures, usually authoritative-looking men in ties, always translate— they're iconographic. By starting the scanning process at even slightly different points, the distortions would be radically different in both their structure and what they might evoke in the viewer.

It is like a movie without the advantage of persistence of vision to put it back together—make it whole.

Those first images I did were very crude, but also they were digital so you could manipulate them to a certain degree. The tools, the software tools available, were very limited—you could reverse it and stuff like that but nothing *that* interesting. The main point was to get it into a

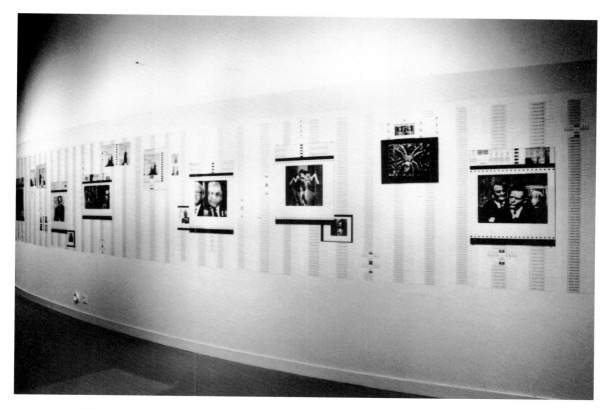

■ Installation of Print Out at Rennes, France, 1988, 60″ x 324″

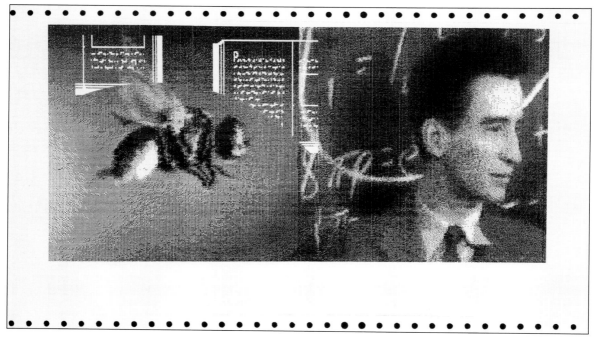

■ Print Out #14, 1986, 16″ x 24″

digital format so I could do all the other digital things I could do with text and other kinds of information, so it all joins into one seamless image.

So that was the first reason, to be able to put the writing and the picture together. But you went way beyond that.

The text and picture were now in one domain, although crudely at the point of the wall-sized *Print Out* piece. What it made possible, however, was a new kind of picturing device within the world of information. The world of broadcast TV always struck me as an inherently collaged place—camera image and text were always melded together—the talking head and the graphic text information were in the same place as far as viewers are concerned as they watch an anchorperson or a weather forecaster. The weather forecaster and the satellite photo are functionally in one place; the weatherman "lives" with images and interacts with them because they are functionally really there. We don't think about chroma keys when we see them pointing at clouds and storm fronts, we accept them as being in one special weatherperson world. "Photo manipulation," within the world of photography, always implied a move away from reality. But text/image manipulation within the world of broadcast TV is the norm. I now had a camera-machine that could picture that. In a sense, that was the exit point for me from photography in the traditional sense.

It really is completely different. For example, the photographic idea of losing information each time you generate a new copy or combination doesn't apply.

Only in the sense that you don't "lose" information as you transform each time. The idea of generation, meaning a way to chart the distance from the original, ceases to have the same meaning it does in photography. In the digital domain, the copy is identical to the original. This obviously has certain conceptual implications. A lot of *Seattle Subtext* looks digital but none of it really was. It referred more to the compilation or collage that is the printed page, where we are already used to text and picture elements going together through a mechanical process—offset printing. The next work, *Print Out*, took another step, in that the imagery was a digital transformation of a video frame, but I still needed photography as a final printing medium as well as Xerography. So I was still only halfway to where I wanted to be. If I had been able to do it all electronically, I would have.

And ultimately you have. The TARGA board has allowed you to run the generations and produce a final product without resorting back to photography. Even the airbrushing you added to some of the* Print Out *and* Portraits and Plans *series—you can get that effect by going in and altering the image pixel by pixel with TARGA.*

Right, any manipulations are now digital. At the point of the *Print Out*

*A proprietary computer component that converts analog video signals to digital signals.

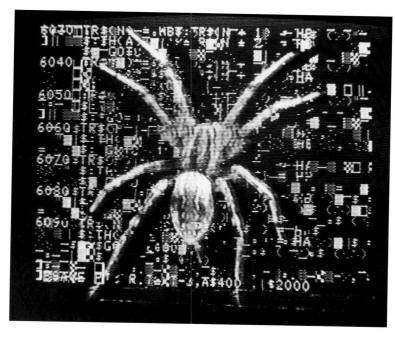

■ Print Out #E4, Spider Code, 1985, 15″ x 12″

installation I still wanted to refer to a tactile experience, to really feel a wall, and a wallpapering of its surface against which we see digital images emerging. The wallpapering background was composed of data base listings of a huge collection of videotape segments, acting like a web or network or skeleton of possibility. Computers allow access to huge data bases, but you can only see a screenful at any one time. *Print Out* broke out of that frame and saw all the potential data bases at once, with selected instances "blown-up" or "retrieved" as digital photolike pictures. Those images are mostly of the talking-head power figures, and it is as if I had forced them to really "live" inside and among their dispassionate figures, charts, schematics.

With the TARGA board I got into real-time frame grabbing—stopping and digitizing a frame of video rather than compiling it over time. Real-time in this context simply means a thirtieth of a second. Since the world you are "photographing" in is delivered to you in that time frame, there is no need to grab any faster than that—you could only get part of a picture if you did. I had a small-scale inkjet printer that I could use to make 7″ x 9″ prints, and I began by physically collaging these small prints together manually—the *Portraits and Plans* group. The final step toward total digital was using the Jetgraphix 24″ x 30″ industrial printer in Los Angeles. At that point there was no more hand manipulation of any kind.

What do you actually send them so they can make the print?

I send the final image to Jetgraphix by disk, but it could also be done entirely through a modem which would mean that the only thing I am sending to Los Angeles to be printed is pure digital information encoded

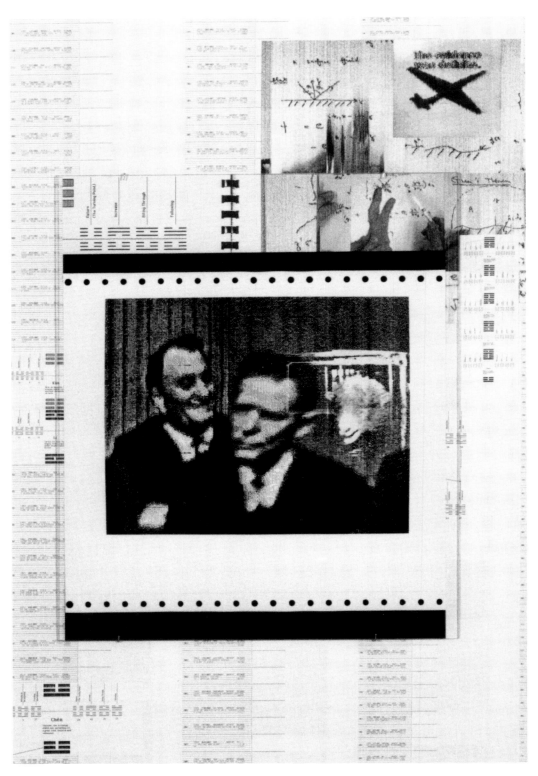

■ Detail from Print Out installation, Seattle Art Museum, 1984, 48″ x 300″ (overall)

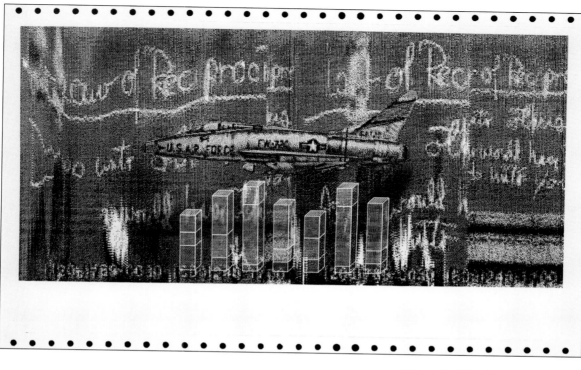

across telephone lines—no physical object at all.

Beginning with double-exposing the mathematics blackboards, one frame at a time to build up an image of the notational information recorded there, your progression has taken you to finer and finer forms of digitization, building images out of smaller and smaller atoms of information. In both the Mathematics *series and the current weather chart imagery, you are dealing with abstractions of real, concrete phenomena to begin with. And yet as you achieve greater aesthetic distance and more layers of abstraction, you are still interested in producing a final product in some tactile form that resembles traditional art, a beautiful object made by hand. Otherwise you could just make disks and pass those around.*

I guess so. In some ways I'm interested in the computer screen as the final thing to look at. If I'd gotten involved in temporal presentations, sequences, etc., the best viewing place would be at the computer screen rather than a video tape or a laser print.

What is the relationship between your use of the automaton, the box that you load that gives you back imagery that's determined by its nature and design, and your need for generations that you can manipulate and control to make pictures?

I think that there are two key concepts here. The first is the idea of an arena, a bounded place. It could be a game space, like a football field or a boxing ring, or the blackboards in the mathematics building at the University of Illinois. The second concept is the automaton, the machine that has certain unpredictable, non-trivial operations or ways it can "see." I

decide on the arena, build the machine, and then let it go. I then modify the arena, or the machine, or both, and finally I modify the finished work in an interactive way. If you look at the different bodies of work I've done, each one can be seen as having its own arena, its associated automata, and a final compilation of parts by me into a viewable form and format.

A traditional form you adapt to your use is the figure/ground relationship. You once referred to the background of computer language columns in the Print Out *installation piece as being a ground. The images superimposed on the ground were to have a more than formal relationship to it, though.*

I think of the Xeroxed wallpapering of the data base listings as the studs behind the wall, the structure that is really holding things up. In *Seattle Subtext* such listings suggested to me all the connections between facts and images that are hidden from the reader, but are made for us by editors. In the *Print Out* piece, one sees virtually all the possibilities, and the ones presented to you as "blow-ups" are only one set of selections among many possible. It's like looking at the telephone switching system in its entirety, knowing that any single phone call connection is only one of many. In photography, we know that there is an entire world outside the frame, but we know it must be more "real stuff"—the rest of the mountain, the other people off to the side, etc. We are familiar with the subtle ways in which photographic framing can conceal as much as reveal, but in the digital domain, in the world of electronic information, the situation is much more complex—and the deceptions potentially greater. So the *Print Out* piece simulates the field of choice and shows that what you see isolated as full-blown images are only some of many possibilities.

One of the first Portraits and Plans *pieces continued this theme—the one that has a pencil turning into a rocket. That's a pretty complicated structure: the background as the source of the figure and the potential source of many more figures.*

It also has a certain humility—if you want to read it that way: this picture is not from nowhere. And it is not completely from my imagination. It's from this source that presumably other people could draw from as well.

Is that related to your inclusion of pictures of your own life and your family, some from before you were born, in Seattle Subtext? *Those were the many possibilities against which you are only one—or a number of progressive selves?*

Yeah, that's basically what's going on there, using the topic sections convention of *Time* magazine. *Time's* self-proclaimed contribution to the process of reporting on the world was to divide it up into bite-sized chunks—World, Nation, Sports, Books, etc.—and to write each section with an interchangeable style and length. I start off by emulating that, even formally with typography and design, but then gradually create imaginary, impossible, or inverted sections that undo the neatness of

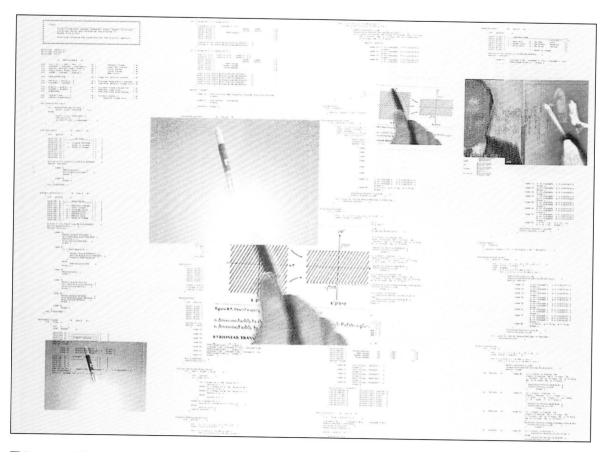

■ Portraits and Plans #10, 1988, 22" x 30"

such a system of reportage. So by the time you reach the last section, World, I have inverted it to be the "world" of my own family—the smallest human unit. Behind that inversion is the belief that the neat, easy subsections that *Time* or any other institution chooses to divide up the world into are, in fact, problematic, not-so-neat, and potentially very limiting ways to look at the world or one's experience in it.

Another somewhat traditional form you use is the sequence. How does that fit into your thinking? It seems difficult for the normal person to relate to sequential manipulation now that the seamless flow of television has pretty much supplanted the news magazine.

This is a very important question. Although the sequential manipulations I employ might seem esoteric, I think that it is the context in which you see the manipulations that causes the difficulty. For example, sports coverage, especially official national games like football, bombards the viewer with incredibly complex restructuring of events—replays, slo-mo, reverse angles, overlays, etc. Yet the average football viewer does not think of himself as viewing "transformational sequences." I think that much of our common experience is fantastically complex and multi-faceted, but because it is so embedded in use value (we just want to know who won the game), we do not reflect on it. When we don't reflect on systems of presentation, we are vulnerable to great manipulation, by others, or ourselves.

It is usually in new areas of inquiry that we are made aware of how transparent our perception mind-sets are. The most vivid example nowadays is in "computer interface" and user programming. It is not totally worked out yet in the way that news magazine or TV news coverage formats have been, so there are still surprises. There are some fascinating experiments going on now with user programming—"authoring languages." Instead of treating programming in the traditional way as a list of sequentially executed commands that then operate on a separate set of data, there is a movement to think in terms of "objects" or "agents" that are little animated critters that send messages to each other. Collectively, it is another attempt to understand how we as humans can mediate our experience. Its strangeness at the moment of 1990 might seem commonplace—even invisible—by the year 2000. In that sense, the general culture is where yesterday's avant-garde disappears and is no longer reflected upon as a particular way of seeing with built-in limitations. We use it, and do not think about what it doesn't allow us to do. Art can be a continual wake-up call that says, okay, what glasses are you wearing now?

You seem to have a set of images, symbols if you will, that you have used over and over. I'm not absolutely sure what they refer to but there seem to be certain ones that have moved through your work from one project to the next. For example, there are some fairly clear elements, like military hardware, obvious excerpts from media formats, like the weather readers, and the omnipresent handwriting, what you call the point of notation. But there are others that are more ambiguous: well-

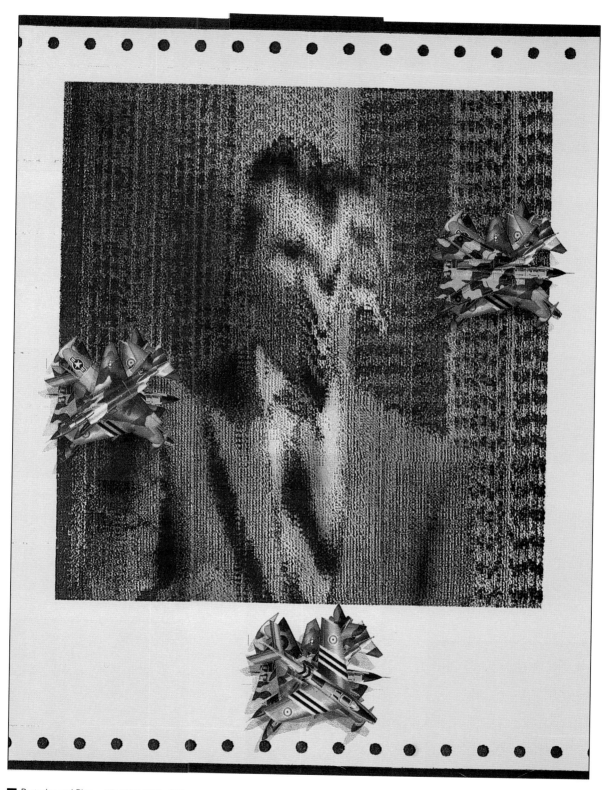

■ Portraits and Plans #2, 1988, 22" x 30"

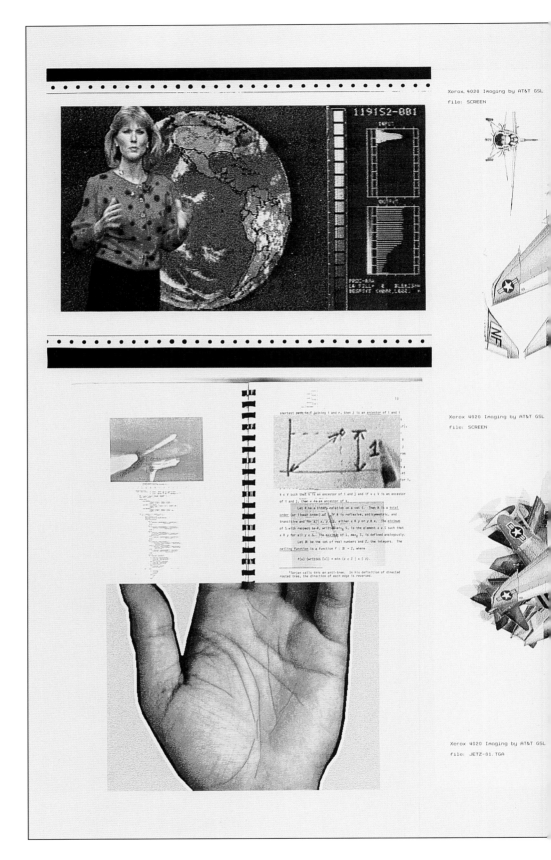

■ Portraits and Plans #3 and #4, 1989, 30" x 40"

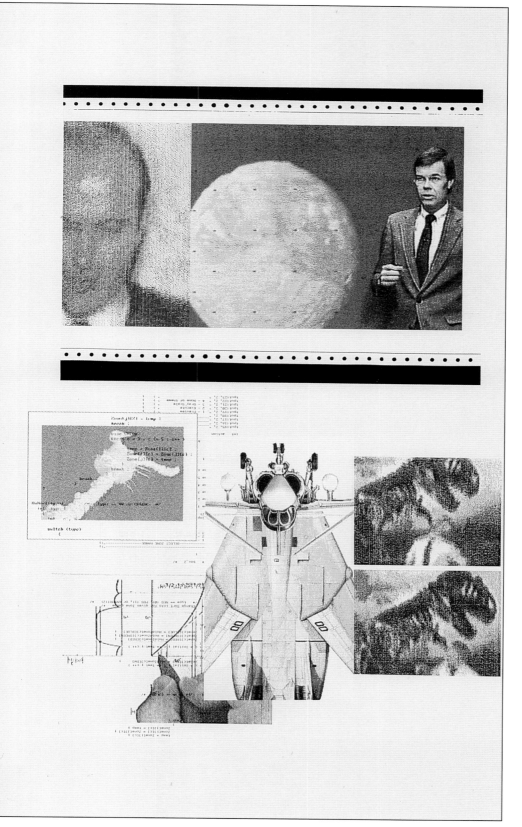

dressed people that remind us of either politicians or business men, usually looking either ominous or buffoonish. You referred to them earlier as power figures. Could you talk a little about the literal and nonliteral references in your work?

I don't know that the distinction is between literal and nonliteral so much as it is between familiar and unfamiliar. In the math pictures, for example, even though chalk messages on blackboards are familiar, the prints I produced were not, and they were certainly not literal. As a result, the viewer dives into that new space to figure out what is going on in there. In the *Cards* and the other digitized work, the figures and fragments are much more familiar, and evocative. The math pictures reinterpret traces left at the math blackboard site, but the mathematician is gone. The *Cards* include the hand of the maker and often the maker as well, who is pictured working on models of the world and modes of analysis we are familiar with—weather, science, business. In another way, it is simply the difference between the arcane world of higher math versus the ever-present and familiar arena of broadcast television and the players who live there. As far as specific elements or subjects that I repeat—I guess they are the characters that show their faces.

I meant that you seem to be building a collection of icons that you re-use and laminate new references to very deliberately. You mine your old work for new material and reshape the material as you go.

Yes, that's true. Part of that is simply the continuity of whatever compels me to investigate the kinds of situations I do, reflecting my particular fascinations, fears, experiences. Part of that also has to do with the bigger questions that concern us all: I'm asking questions about the questions we ask. If there are recurring figures and situations in broadcast TV, it reflects the overall strategy of that media. My task is to isolate an arena, build the "machine" to view it with, and then respond to the visual results.

So you are allowing your various automata to shake out icons, sometimes as survivors of a process but also because they keep turning up.

Yes, and because of the continuity of the automata and the sites they are aimed at, the recurring figures get recycled and take on new meanings. The "power figures" who made it through the crude Apple digitizer really are interchangeable and very graphic: the uniform of a tie, a white shirt, and a coat is so graphic that it persists through all kinds of transformations—which makes it a good metaphor. The site of notation, where people figure things out in writing and drawing also persists through many transformations. TV weather maps are doubly interesting to me because when computers first achieved wide usage, one of the applications was to try to predict the weather by building complex models. Now the high-speed computation made possible with super computers begins to approach the edge of randomness to the point where weather prediction may be possible.

I like your connection of weather prediction with the news—reduced

■ Cards: Mathguy, 1989, 24" x 30"

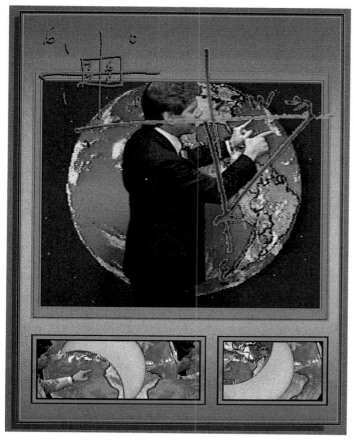

■ Cards: World 2AA, 1989, 30" x 42"

■ Cards: Monitor, 1989, 24" x 30"

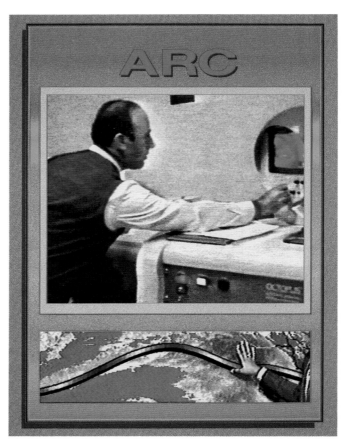

■ Cards: Sower, 1989, 24" x 30"

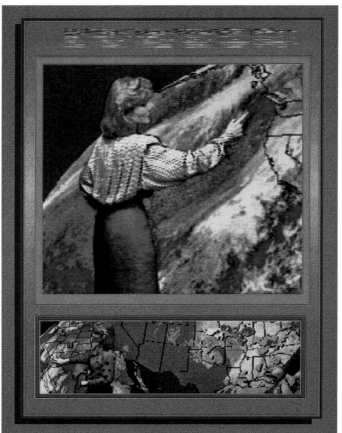

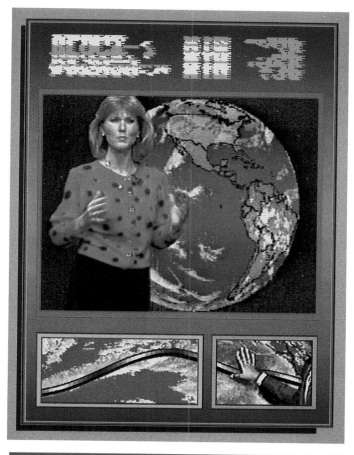

■ Cards: Woman, 1989, 30" x 40"

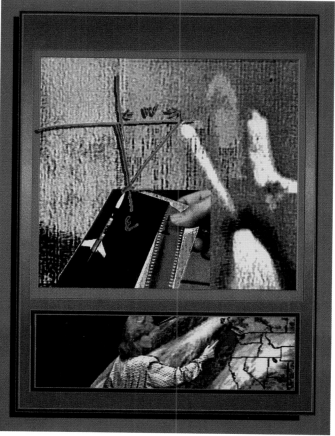

■ Cards: Triangle 3, 1989, 24" x 30"

information about world events. They are equally unreliable even though the meteorologists and journalists are always so cheerfully confident in the face of crisis and disaster and things going wrong.

In *Cards* and in *Portraits and Plans* a high percentage of the people depicted are connected with things going wrong. But the news isolates the "going wrong" into neat models. Metaphorically, the weather is the clearest case of human beings working with a model. We know it is an illusion that they are laying their hands on the world. People putting their hands on things work best when they are seen indirectly—in some formally abstract way.

The largest Portraits and Plans *piece seems to me to function loosely like a cartoon, with a sequence of elements that can be connected to form some conclusions that are both funny and darkly ominous. Our eyes move from a serious-looking weatherwoman with the living earth behind her, to a fighter plane next to a human hand, to one of your "authority figures," to a serious man in a tie next to what appears to be a dead planet. Below this sequence are massed fighter planes, lines on a palm implying augury or prediction, stills from the space shuttle disaster, and what appears to be a man being eaten by a dinosaur. There is a variety of text, most of which almost makes sense, and two examples of the site of notation. It is your familiar cast of characters—which is also cartoonlike.*

I am interested in using explicit structures to generate multiple and ambiguous meanings. The move from the cartoon, as seen in *Print Out*, to the card deck in *Cards* is not great, at least in my view. I have always been fascinated by both. A conventional playing card deck is a kind of pre-fab story generator. When dealt a hand, you don't expect or want to suddenly see a brand new suit or face card. In a cartoon, you know and expect the characters, the quick narrative—a visual turn of events.

Within a predictable arena new "stories" are constantly generated.

Right. You read cards like a kind of story: you've got a good hand or bad hand and a strategy for improving it within the rules. The Tarot deck is an extension of this, although it was in fact the precursor to our contemporary card deck. If you take the Tarot tradition seriously, which I don't particularly, it can be seen as a visual machine that in the right combinations can regenerate all knowledge and serve as a pathway to transcendent consciousness. And it is composed of these cryptic symbols that aren't part of a story in a direct narrative manner. But there are individual figures and symbols that function narratively as they recur in various situations, sometimes as the major element, sometimes as background. This was my inspiration for *Cards*—some elements are seen in two of the *Cards*, some in three or four, some just once. Also, the connections between the cards are usually conceptual and not visual. For me, the Tarot is a metacartoon.

Seattle Subtext, which is more complicated than the *Cards*, works

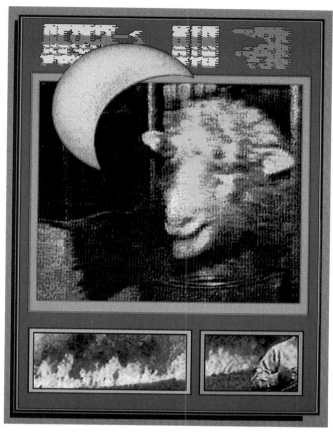

■ Cards: Moon Ram 2, 1989, 30" x 42"

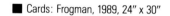

■ Cards: Frogman, 1989, 24" x 30"

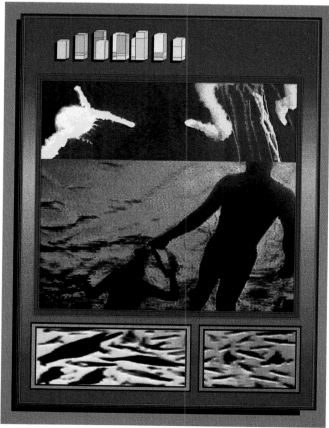

like the Tarot in the sense that its flow is sometimes narrative, sometimes causal, sometimes visual. For example, the woman screaming and falling is a literal narrative like a film, that's why it's in the *Cinema* section. One moment after the next, purely visual. There are also some written texts you see interweaving throughout the series. Some graphic configurations are repeated and some recognizable faces. *Seattle Subtext* is by far the richest, just in terms of moving from one idea to the next, of anything I have done. As a result it's very, very dense. I wanted the *Cards* to be the opposite—really spare.

Sometimes in your work the multiple kinds of connectedness or transformation seem to be at cross purposes.

Sometimes. In *Cards* there's one—a fire along a ridge and a guy running off the edge of the frame with a tripod. Initially, you have to think about it literally, which is the opposite of your response to all those weather-people who have hands on a model—this is a guy running away from the real thing. I grabbed a square section out of the whole frame and it is a really bad representation of that event. I can't even remember what the real event was. But it evoked something larger than the specificity of that event—a human running away from reality carrying his little measuring or recording device. That's where I think, for me at least, the selection of imagery becomes crucial. It's not just that it's intellectually or politically correct, but that it has some charge, even if it is cryptic. Often when I look at some other culture's holy books—the exotic symbols—even though I have no idea what is going on, the visual aspect of it is profoundly evocative. I am interested in how that works—how the power of thought gets into the visual realm.

The Mathematics *series works on that idea too. Of course, there could be a really powerful graphic image that was based on some inconsequential or goofy idea...*

Sure, and that is the point of some of the images I lift—today the insistence of visual imagery is often harnessed for trivial and commercial purposes. Logos have diluted and sometimes replaced real icons. And logos themselves have become more abstracted and distanced from what they represent. In the 1920s and 1930s they were still connected to the product in some direct way, like the shells and dinosaurs representing geology and fossil fuel for the oil companies. When I was a kid, there was a gas company called "Signal," whose logo was an old style traffic signal, the kind with a mechanical arm. Now we have a word, Exxon—that was computer generated based on a consultant-dictated list of "nice" sounding syllables. Sometimes I choose what you are calling icons quite at random. I can turn on the TV and there will be something on there that I end up using, and I think, well, I'm glad I turned it on today.

The fact that you could turn it on any day and connect with something seems like a typically American way of compiling references. Walt

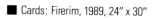
Cards: Firerim, 1989, 24″ x 30″

Cards: Bearman, 1989, 24″ x 30″

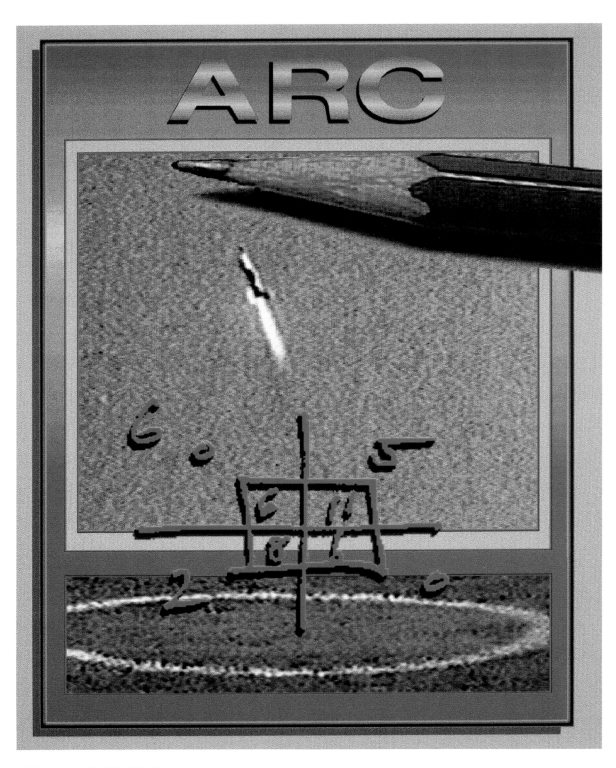

■ Cards: Arc V2A, 1989, 24″ x 30″

Whitman was that way—he finally honed himself down to where he could find a poem anywhere.

I would shift the emphasis to the compiling rather than the references. I think that it is possible to find a way to construct relationships between elements that are not in themselves poetic if you can build a device to correlate them—the idea of the automaton again. The *Cards*, and previous series, use certain visual strategies to that end. The hard-edged framing of each card, slightly different in each one, gives me a way to create emphasis, as does having some elements reappear in different enlargements. The framing also has an explicit reference to computer "windows," the new programs for juggling many kinds of information at once. An important point, however, is that virtually all of the elements that I use in *Cards* have already been carefully created to carry meaning by a TV studio director or designer—I am not looking at Nature. When I make my visual machine (if you can think of the picture as a machine), I am calling attention to its construction. When a TV station creates its own news package, the intent is to make the structure invisible, transparent, objective.

You once said something about the programs you use leaving a few holes you could see through into the wilds of the computer. What did you mean by that metaphor? What do you expect to find in there?

To give an example, when you turn on an IBM-type computer, it first goes through a basic start-up procedure, loads DOS, the disk operating system, and then waits there blinking at you, ready to run a program. If you start messing around with the basic configuration of your disk operating system, you can become more powerful in relation to what you can make it do, but you can also make some serious mistakes.

So you didn't mean unknown territory in the sense of feeling like Marco Polo going in there?

I did mean that, too. It feels wild because you're not protected at that point. You can do serious damage—you can really cut yourself—or just go recklessly into some other weird land and then you realize how little you really do know.

It seems when you talk about the computer and its technical aspects, it's all available to you for idea mining as well as being a tool.

Yes, the computer is an endlessly spiralling collection of interconnecting parts, both mechanical and conceptual. There are many dark sides to this as well, such as the very rudimentary way in which people react with it. There is something scary in the way a CRT pulses as an image, and the way it pulls you in by giving such instantaneous feedback—a hypnotic effect.

Does that make it particularly useful for making art now, in the middle of a technology storm? Has it become another mode of representing by abstraction?

It is a highly charged image-making device, and I am drawn to it in part because it is in such a state of development. It is certainly not more privileged or pure than any other media and shares many of the complications and problems of the related media of television, film, and photography.

Once we "got" representation as a way of communicating, we started a process of elaboration on the theme that ended, ironically, with its becoming transparent— pictures become windows. It is odd to think of innovation in the area of finding a new limitation or frame beginning with opacity.

Or it could be the opposite, like my childhood experience with the crayons. In a very rough way you could say that we are talking about a fascination with an unexpected relationship—not just between parts but between parts and frames. In that context, I think frames and windows are distinct. A window implies a hole in the wall of an enclosed space. A frame can go anywhere. At age three or four, I was used to using one crayon to depict or embellish one thing at one time. When I discovered using several crayons in parallel, however imperfect, it was not just a way to draw more but a departure from a previous use. Why was it so powerful to me then, with the crayons? The crucial thing was moving to the wall as a new site. It was so powerful that it was inspirational— I got carried away.

Articulation and coherence don't normally come together for little kids. Usually those are the things that are the furthest apart. When you try to articulate something as a little kid, it's rarely coherent. You all of a sudden were in control of an automatic articulated coherence.

And the frame of the coloring book for that instant was gone.

Paul Berger, born 1948 in The Dalles, Oregon, lives in Seattle. He has taught at the University of Washington since 1982 and is currently professor of art. Berger has exhibited nationally and internationally since 1969; his work was included in the International Festival of Electronic Arts, Rennes, France, in 1988. In 1983 Berger curated the exhibition *Radical Time/Rational Space* at the Henry Art Gallery, University of Washington, Seattle, and co-authored the catalogue with Leroy Searle and Doug Wadden. His *Seattle Subtext* series was co-published as a book by the Visual Studies Workshop, Rochester, New York, and Real Comet Press, Seattle, in 1984.

Education

1973 M.F.A., The Visual Studies Workshop (Program in Photographic
 Studies, State University of New York, Buffalo)
1970 B.A., University of California at Los Angeles

Awards

1988 Seattle Arts Commission,
 Seattle Artists Fellowship Grant
1986 National Endowment for the Arts,
 Visual Artists Fellowship Grant
1979 National Endowment for the Arts,
 Photographer's Fellowship

Public Collections

The Art Institute of Chicago
Australian National Gallery, Canberra
Bibliotheque Nationale, Paris
Center for Creative Photography, Tucson
California Museum of Photography, Riverside
International Museum of Photography, George Eastman House,
 Rochester, New York
Los Angeles County Museum of Art
The Museum of Fine Arts, Houston
San Francisco Museum of Modern Art
Seattle Art Museum
Seattle Arts Commission
Washington Art Consortium

Berger, Paul. "Doubling: This then That." In *Radical Space / Rational Time*. Seattle: Henry Art Gallery Association, 1983.

——————. *Seattle Subtext*. Rochester, New York: Visual Studies Workshop; Seattle: Real Comet Press, 1984.

Digital Photography: Captured Images / Volatile Memory / New Montage. San Francisco: Camerawork Gallery, 1988.

Edgar, Anne. "All the news that's fit to print." *Afterimage,* March 1985.

Eye of the Mind; Mind of the Eye: Photographs with Text. North Vancouver, B.C., Canada: Presentation House Gallery, 1988.

Glowen, Ron. "Perceiving in Series." *Artweek,* February 23, 1980.

Green, Jonathan. *American Photography*. New York: Harry N. Abrams, 1984.

Grundberg, Andy and Kathleen McCarthy Gauss. "Photography and Art: Interactions Since 1946." Cross River Press, 1987.

Henry, Gerrit. "Paul Berger: An Interview." *The Print Collector's Newsletter,* May-June 1980.

International Festival of Electronic Arts. Rennes, France, June 1988.

Kerns, Ben. "On the Photography of Paul Berger." *Northwest Review,* Summer 1981.

Life Library of Photography. *The Art of Photography.* rev. ed. Time / Life Books, 1981.

Miller, Marc H. "Television's Impact on Contemporary Art." *Aperture,* Spring 1987.

Searle, Leroy F. "Paul Berger's 'Mathematics' Photographs." *Afterimage,* March 1978.

Slemmons, Rod. *Stills: Cinema and Video Transformed*. Seattle: Seattle Art Museum, 1986.

Tamblyn, Christine. "Machine Dreams." *Afterimage,* September 1988.